# making

# photographs

# making

**burgher books**

# photographs

## valerie burton

The publisher gratefully
acknowledges the assistance
of Minolta Canada Inc. in the
publication of this book.

Burgher Books
10 Edmund Avenue
Toronto, Ontario
M4V 1H3  Canada

Edited by Meg Taylor and
Laurie Coulter.

Designed by Counterpunch/Linda
Gustafson.

Distributed by:
Raincoast Books Limited
8680 Cambie Street
Vancouver, B.C.
V6P 6M9  Canada
Toll-free order line: 1 800-663-5714

All photographs by the author with the exception of:
page 17 by Katie Dixon; page 58 by Rick Zolkower; page
61 by Alison Chown; and page 62 by Rafael Goldchain.

Canadian Cataloguing in Publication Data
Burton, Valerie
        Making photographs
Includes index.
ISBN 1-896176-07-0
1. Photography – Juvenile literature.    I. Title.
TR149.B87 1995      j770      C95-932081-4

Printed and bound in Canada
95 96 97 98 99   5 4 3 2 1

ACKNOWLEDGMENTS
With special thanks to: my husband, David Milman; Tara
Collins and Dan Collins; Norm Dutcher, Vistek; Penny
Bogner, Tree House Gallery; Becky Wicks; Sabina
Jungeblut; Barb Morelli, Caledon Central Public School;
Mrs. Laurie Pedwell, Humberview Collegiate; Sheila
Wilson and Craig Crone, Smithfield Middle School;
Patrick McCarthy, Metropolitan Toronto Zoo; K-9 Corps,
Peel Regional Police; Canine Vision Canada; Lindsay
Clandfield, Children's Book Store; Rafael Goldchain,
technical editor; Gerry Fabe, makeup artist; models: Renée
Broadway, Katie Brook, Deb and Jim Dixon, Katie and
Ian Dixon, Calina and Daniel Franz-Hernandez, Michael
Goldchain, Sieu Moy Ly, Brittany and Adam Plumb, Janet
Powell, and Rebecca Zolkower.

# contents

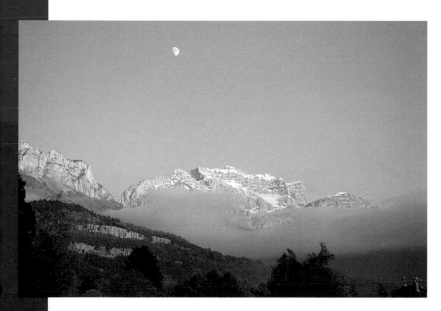

# 1

# choosing what to photograph

There are many reasons to take a photograph:
to preserve a happy moment or
to remember a special event,

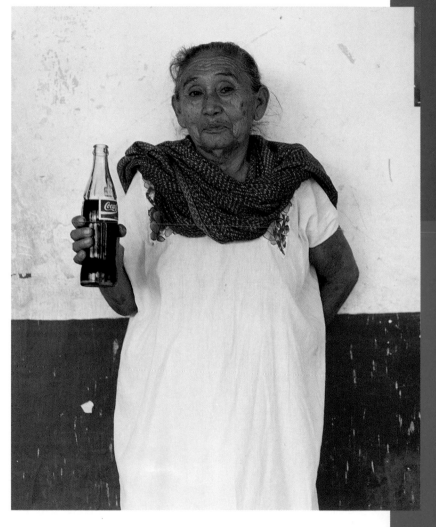

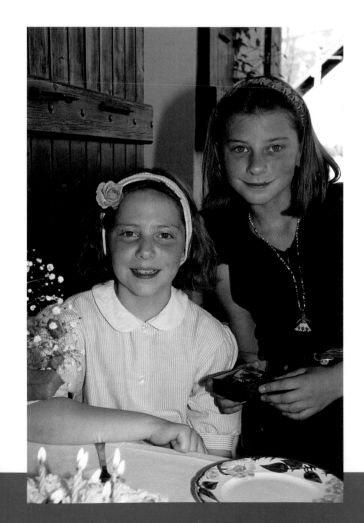

to have photos of friends and family,

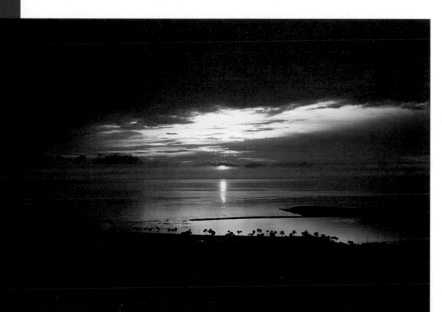

to create a beautiful picture,

to show others how you see the world.

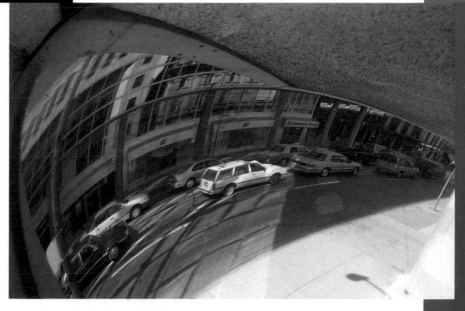

What makes a good photograph? Look at every-
thing around you — people, animals, flowers,
buildings, cars. Take time to notice all the
possibilities for good pictures. You'll find
interesting shapes, mysterious shadows,
bright colors, and unusual patterns.

Every face is unique. Take a photograph
that shows something special
about someone you
know well.

Walk around your neighborhood and take pictures of
your favorite places and things. Try to keep your
photographs as simple as possible. Concentrate
on something you like, and don't put
anything else in the picture.

## 2

Point and shoot cameras and *single-lens reflex* (SLR) cameras are the two types of cameras most people use. The SLR camera is more complicated than the point and shoot camera, but the electronics built into the modern SLR have made it almost as simple to use.

The SLR camera has parts similar to all other cameras, such as a lens, a shutter, and a viewfinder. However, the quality of each part is usually better, and you can make manual adjustments to change and improve your pictures.

### Viewfinder

To compose a picture, look through the *viewfinder.* If there is a built-in border in your viewfinder, only what appears inside the border will be in the photograph.

### Lens

Light rays bounce off the subject of your photograph, pass through the lens, and strike the light-sensitive silver coating of the film. When the film is developed, the exposed *silver* forms a negative image of your subject on the film in which dark tones look light and light tones look dark. This *negative* is printed on special photographic paper to produce a positive image of your subject.

When the lens moves closer to or farther away from the film, the image is brought into *focus* — the image will appear sharp and clear in

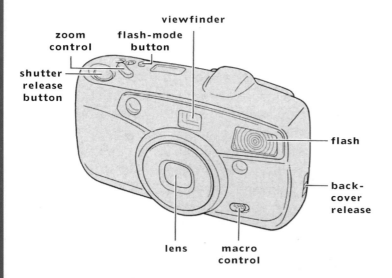

*point and shoot camera*

viewfinder

zoom control

flash-mode button

shutter release button

flash

back-cover release

lens

macro control

the viewfinder. Point and shoot cameras focus automatically. Some SLR cameras can also be set on automatic focus. To focus an SLR camera manually, you turn the focusing ring on the lens until the image becomes sharp.

Different lenses have different *focal lengths,* which change the size of your image and determine how much of it will fit within the frame of your viewfinder.

## Aperture

The *aperture* is the opening in the lens. It can be made larger or smaller by changing the f-stop to increase or decrease the amount of light that reaches the film.

## Shutter

The shutter works like a curtain behind the lens. When you press the shutter release button, the shutter opens and closes in fractions of a second to uncover, then cover up again, the film in your camera. The shutter protects the film from light when you aren't taking a photograph.

viewfinder eyepiece
power button
film window
tripod socket
back cover

## Exposure Settings

When you take a picture, the size of the aperture (how big the opening is) and the shutter speed control the amount of light the film receives. This is called the *exposure.* The film must receive just the right amount of light for the picture to turn out.

In the point and shoot camera, the correct exposure is made automatically. SLR cameras have both automatic settings and manual settings.

If you want to see how the lens aperture and shutter work, open the back of your camera when there is no film inside. Hold the camera up to the light, look through the back of the lens, press the shutter button, and you'll see what the film "sees" when you take a picture.

## Batteries

All cameras use batteries. Check to see what kind your camera uses: AA batteries, lithium batteries, or small round (alkaline) ones. It's a good idea to carry spare batteries if you use your camera often. If you aren't going to use your camera for a long time, take the batteries out of the camera. They will last longer and you won't have to worry that they might leak and damage the camera.

## Flash

An electronic flash allows you to take pictures in very low light or to lighten dark shadows in bright sunlight. In many cameras these flashes are built into the camera body and often work automatically if extra light is needed for a good picture. If your camera has a switch for the flash, you can turn the flash off when you don't want to use it.

    SLR cameras and the more expensive point and shoot cameras have a clip on the top, called a *hot shoe,* so that you can add a bigger flash to light a larger space.

## Film

For the best photographs, use a camera that takes 35mm film. Smaller negatives don't make very good prints. The 35mm film comes in three lengths: 12, 24, and 36 exposures. To decide which to buy, think about how many photographs you plan to take. You can choose from color print film, color slide film, and black and white print film. Keep in mind that it's not a good idea to leave a roll of film in your camera for a long time.

    Think about how much light you are likely to have when you take your pictures. Film comes in different speeds, and each one is given an *ISO (International Standards Organization) number.* For bright sunlight or flash pictures, you might choose a low number such as 100 ISO. For shooting indoors or outside on a cloudy day, choose film that has a higher ISO, maybe 200 or 400.

    Make sure the ISO number is set correctly on your camera. Point and shoot cameras, and

almost all SLR cameras, will automatically set the correct ISO number using a *DX code*, which is stamped on the *film cassette* (the round metal container that holds the film). Otherwise, you must set it manually. It is very important to set the ISO number on your camera carefully because the built-in *light meter* uses this setting. If the setting is wrong, your pictures may turn out too light or too dark.

Store film away from heat. Color film should be kept in the refrigerator if you're not going to use it right away, but be sure to take it out of the fridge a couple of hours before loading it into your camera.

**Loading the Camera:** Always load your camera in the shade, never in bright sunlight. Open the camera back and insert the film cassette into the open slot.

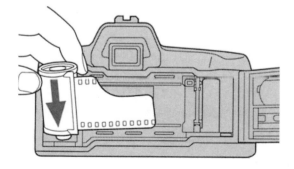

Pull out the leader strip (the narrow piece of film at the beginning of the roll) and place it on the take-up reel on the other side. Make sure that one of the holes on the edge of the film fits over a sprocket (the little teeth on the side of the take-up reel). This must be done carefully or the film will not advance and you will not get any pictures.

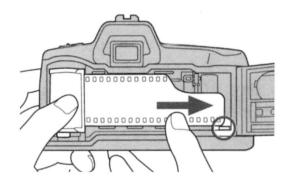

Close the back of the camera and, if your camera does not do it automatically, pull the lever to advance the film counter to 1. If the film does not advance, press the shutter button and try again. If it still doesn't work, it usually means the sprocket did not catch hold of the film properly. Open the back of the camera and start over.

**When the film is finished,** it must be wound back into the cassette before you can open the camera to take it out. If the camera automatically rewinds the film into the cassette after the last frame has been exposed, a tone or beep will sound when it's safe to open the camera. If your camera is not automatic, rewind the film until you feel a release in pressure (check the film counter to be sure it's on 0), then open the camera and remove the film cassette.

**If the film becomes jammed,** or if you are not sure it has rewound into the cassette, you can open the back of your camera to check if you do it in complete darkness. Try this in a bathroom with no window or in a dark closet. There must be absolutely no light. If you can see light under the door, stuff the crack with a towel.

The film can then be safely removed. You can wind it back into the cassette in the dark if you turn the spool of the cassette by hand until the leader strip disappears. Working in complete darkness takes practice. Try loading and removing a spare roll of film with your eyes closed. This will help prepare you for an emergency.

## Photo Care

Handle prints (and negatives) carefully by the edges to avoid fingerprints. Store them in albums or in boxes away from heat and bright light.

Photographs should be framed with a *mat* so the surface is not touching the glass. If you frame a print, don't hang or display it in direct sunlight or the colors will fade.

If you glue a print into a scrapbook or onto art board, use mounting glue made for photos. Other adhesives, such as rubber cement, will damage your prints.

## Camera Care

Keep your camera free of dust and dirt by storing it in the camera case. Remove any dust on the lens; dust can scratch the lens and make marks on your pictures. You could buy a lens cleaning kit, which contains everything you need. First, brush the lens with a lens brush. Then use lens cleaning fluid and lens cleaning tissue to gently wipe the surface in a circular motion. Do not leave your camera on a sandy beach or in direct sunlight.

Load the film into your camera and set the correct film speed on the ISO dial if it is not set automatically (see page 13).

Hold the camera steady with your right hand, leaving your index finger free to press the shutter button. Balance the camera carefully with your left hand. If the camera moves when you are taking a picture, even just a little, the picture will be blurry. Use the neck or wrist strap on your camera so that you won't accidentally drop it.

Make sure that nothing is covering the viewfinder, lens, or flash, such as your fingers or hair, or the camera strap. Stand with your feet slightly apart to keep your balance, or crouch, or sit down to take the picture from a different viewpoint.

When you press the shutter release button, do it gently. Pushing too hard will move the camera downward and blur the picture.

Remember not to stand too close to the person or object you are photographing. Most point and shoot cameras will not focus closer than 3 to 6 feet (1 to 2 m). If you get any closer, the picture will be fuzzy.

Pictures taken with a 35mm camera are rectangular in shape. Holding the camera horizontally will make a horizontal picture. Do this when you want a lot of background in the image.

to keep your story simple. If you are taking a picture of your friend John, he should be the *center of interest*, the most interesting thing in the picture. Perhaps the two of you spend a lot of time together playing baseball. Try to photograph him with the equipment you use when you play baseball, or take a picture of him on the baseball diamond with a simple background. If he's relaxed, your pictures will turn out better.

You can also hold the camera on its end for a vertical photo of your friend's whole body or of something else that is tall, like a tree.

To make an interesting picture, you need to think about what you will include within the frame and what you will leave out. This is called the *composition* of your photograph. Composing a photograph is a little like making a painting or drawing a picture — you must plan ahead.

Everything within the frame of your picture tells a story about the subject, so it is best to try

Look carefully at what you want to photograph and decide what you like most about it. If your subject is a person, it might be the eyes or the hair or perhaps the shape of the hands. Avoid shadows on faces and focus carefully. Move to the left or right or stand up or crouch down, changing your *angle of view* to improve your picture. Change the position of your subject to remove a background that is distracting. (See Chapter 5 for more information on composition.) Try to make a portrait by photographing the part you find most interesting. A portrait doesn't have to be of a person's face.

# 4

# how to use
# an SLR camera

The basic steps for using the single-lens reflex camera are the same as for the point and shoot camera, but the SLR has special features that can help you change and improve your pictures. The SLR is a little bigger and heavier, so be careful to hold it steady when you take a picture. Before you start, make sure to set the ISO dial on your camera for the type of film you are using, if it is not set automatically.

When you look through the viewfinder, the image will probably seem blurry until you focus the lens. Turn the focusing ring on the lens until the image becomes sharp. If you are using automatic focusing, press the shutter button lightly and the lens ring will move by itself to bring the image into focus. The camera will probably beep when focusing is completed.

## Lens Aperture

The lens aperture is divided into *f-stops,* which change the size of the opening in the lens.

A bigger opening (for example, f/4) lets in more light and a smaller opening (for example, f/16) lets in less light. Each change in the aperture, say from f/8 to f/5.6, is called a one-stop change. If you make your aperture one stop smaller to let in less light (for example, by moving the setting from f/8 to f/11), you must also slow the shutter speed one stop (for example, from 1/250 second to 1/125 second) to keep the same exposure. (For more on shutter speeds, see page 20.)

## Depth of Field

With the SLR camera, you can use the different apertures to change the *depth of field* in your picture. If you are photographing a landscape and you want everything to be in sharp focus, set the lens at the smallest aperture possible. (When you point the camera at your subject, the light meter built into the camera will calculate the correct f-stop and shutter speed.)

Focus carefully on the most important object in the landscape, push the shutter button, and everything should turn out sharp and clear, from the area nearest the camera to the area farthest away. You might have to use a high-speed film (for example, 400 ISO film), which will allow a fast enough shutter speed so that you can hold the camera without using a tripod.

When you are photographing a single subject such as a person, dog, or sports car, you may want to simplify the background by making it look fuzzy. Focusing carefully on your subject, set the lens at a large aperture (for example, f/2, f/2.8, or f/4). Your built-in light meter will tell you the correct (faster) shutter speed setting for the exposure. If you've focused carefully, your subject will appear in focus and the background will be fuzzy and much less distracting. Be careful not to put objects in front of your subject as short depth of field will blur them also.

This technique is called short depth of field and is often used by professional photographers. You'll see many examples of it in magazines, especially in sports or fashion photography.

*short depth of field*

*long depth of field*

## Shutter Speed

The speed at which the shutter moves to uncover and cover the film during exposure is divided into portions of a second, called "stops." Changing your *shutter speed* one notch from one speed to the next is called making a one-stop change (like the one-stop changes on your lens aperture). The speed usually starts at 1 second (very slow) and moves to speeds of up to 1/4000 of a second (very fast). You can safely take a picture holding the camera steady at 1/60 second or faster. If you take it at less than 1/60 second, your picture may be blurry unless you use a tripod to hold the camera steady.

If you are photographing sports or moving cars, you will probably want to freeze the image to stop the action. Set the shutter button at a fast speed (1/250 second or faster). If you have bright light and fast film (for example, 400 ISO), the faster the shutter speed you use, the better. Try 1/1000 second or 1/2000 second. Use the correct, larger aperture indicated on the light meter, probably about f/2.8 or f/4. If the shutter speed is too slow (below 1/125 second), the movement of your subject may be blurred.

## Exposure

As described in Chapter 2, exposure is a combination of the correct aperture setting (the amount of light entering the opening in the lens) and the corresponding shutter speed (the speed at which the shutter moves to allow the light to reach the film).

When you open up the lens (for example, by moving the setting from f/8 to f/5.6), you make the aperture a little larger to let more light hit the film in your camera. At the same time, you must increase the shutter speed to allow less light through the shutter if you want to get the same

exposure. Let's say your first picture was made with the lens set at f/8 and the shutter speed at 1/60 second. Your second picture was set at f/5.6 and 1/125 second. These two pictures were made at exactly the same exposure and will turn out identically because the same amount of light was allowed to reach the film.

Some changes in exposure are made with the f-stops and others with the shutter speed. It will depend on whether depth of field or stop action is important to your picture.

If depth of field is more important to your image, first set the aperture on the lens, then adjust the shutter speed according to what setting your light meter tells you is correct for that f-stop. If you're taking action photos, choose a fast shutter speed first, then set the f-stop for that shutter speed. (See page 22 for information on automatic settings.)

When you look through the viewfinder, the light meter will take a reading from everything you see in the viewfinder frame. You will find that the meter can't "read" correctly any color that is very light or very dark, unless all the color in the image is about the same tone. If you fill your viewfinder with sky or snow and try to take a picture of a person standing in the middle, the person will turn out too dark. If you do the same thing with a person in front of a dark wall, the person will be "washed out," or too light.

Find something that is a medium color, a color like pavement gray or grass green, and take the exposure reading from that. Your meter will give you the correct exposure if you take your reading from this average tone. Make sure this mid-tone object is in the same light as the main subject. Fill the whole viewfinder with this medium color and set your camera. Once this exposure is set, step back and frame the image you wish to photograph, then take your picture.

If you have trouble figuring out the correct color to use for an exposure reading, you can buy an 18% gray card. If you put the gray card in the same light as your subject, it will give you the correct reading. Place the card very close to your subject and hold your camera about 6 inches (15 cm) away from the card to take the reading. Be careful not to block the light on the card with your body. Set your camera to the exposure indicated by the light meter, put away the gray card, and reposition yourself to take the picture.

Make an exposure without the gray card and then use the gray card to check the reading for the next exposure of the same subject. You won't

want to carry a gray card all the time, but it's a great way to learn how the light meter works (and to verify that your own exposures are correct).

If you're not sure about the correct exposure, and the photograph is an important one, take one at the meter reading and then bracket it with two more. *Bracketing* is changing your exposure setting to overexpose the next frame by one stop and underexpose the following frame, also by one stop. You will then have three negatives: one at the correct exposure according to the meter reading, the second overexposed, and the third underexposed. For example, if the correct exposure is f/8 at 1/250 second, make another at f/8 at 1/125 (overexposure) and a third at f/8 at 1/500 (underexposure). You can also bracket by changing the f-stop if the shutter speed is more important. Bracketing ensures that you'll end up with at least one good picture.

## Automatic Settings

There are three basic automatic programs. Use "aperture priority" when depth of field is important. "Shutter priority" gives you speed control to stop action for fast-moving subjects. There is also a program setting that gives the camera total control over all exposure settings.

## Normal Lens

The *normal lens* (the lens that "sees" the same way you see) is a 50mm lens for a standard SLR camera. A 50mm is a good all-purpose lens and is usually purchased with the camera body.

When certain pictures (for example, portraits of people) are shot with this lens, distortion is sometimes caused by the angle of view. This is the angle at which the camera is held when pointed at the subject. For example, hands sometimes appear larger than the person's face if they are in the foreground (in front and closer to the camera).

## Wide-Angle Lenses

*Wide-angle lenses* are used for landscape pictures, or photographs of streets or buildings. The most common wide-angle lens for an SLR camera is a 35mm lens. (The 28mm lens is also fairly common.) This lens reduces the size of what you

*normal lens*      *wide-angle lens*      *telephoto lens*

see so that you can get more of the subject into the picture. A wide-angle lens provides long depth of field, even at larger apertures.

## Telephoto Lenses

*Telephoto lenses* magnify the subject, bringing it closer and making it larger within the frame. They are good for street or sports photography, and for portraits of people. Telephoto lenses have a shorter depth of field than normal or wide-angle lenses. If the subject is close to the camera, the background often comes out slightly blurry, even at f/11 or f/16. Very long telephoto lenses (200mm or more) are large and heavy, and may require a tripod to hold the camera steady. The telephoto lenses most often used are 85mm to 200mm.

## Zoom Lenses

*Zoom lenses* are the most useful of all lenses, especially for SLR cameras with automatic focus. They combine, in one lens, focal lengths from wide angle to telephoto, which allows you to take a wide variety of photographs. Modern zoom lenses produce sharp images, even when the photographs are enlarged.

## Changing Lenses

You can change the lens on an SLR camera any time you are not pushing the shutter button. The closed shutter will protect the film from accidental exposure as long as the camera back is safely shut.

Do not buy a good camera and a cheap, poor-quality lens. Your pictures will not be sharp, and you will be disappointed. It is the lens that makes a photograph look good. If you have a limited budget, consider buying a cheaper camera body and a more expensive lens.

## Used Equipment

Used equipment, in good condition, can be a smart choice. If you buy it from a camera store, the store will give you a warranty for a certain number of months; if there is a problem during that time, the store will repair the equipment free of charge. Before you make your final purchase, some camera shops will allow you to take the used equipment to the manufacturer's local distributor to have it tested.

## Tripod

A tripod is a metal stand for your camera. It has three adjustable legs and a threaded bolt on top that attaches to the tripod mount on the bottom of your SLR camera. Some point and shoot cameras also have these mounts.

Tripods are not expensive, and used ones are available. Choose a tripod that is heavy enough to support your camera and any large lens you might want to use. There is nothing more dangerous to your equipment than a flimsy tripod that can be knocked over easily.

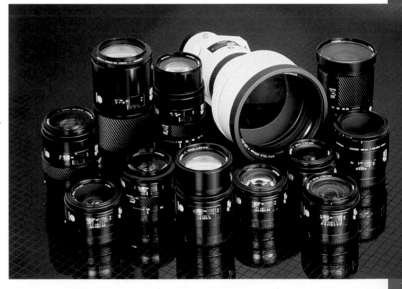

# 5

# design and composition

When you take a photograph, you create something new by making a series of choices about what you see in the world. Putting a frame around a subject removes it from everything around it. Through this framing, you create something separate from the original subject — a photograph.

There is a lot to consider before you press the shutter button. Arrange the things in your image so that the composition is interesting. Look at what you want to photograph through your viewfinder to get an idea of how it will look with a frame around it. Hold the camera so that the framing is horizontal, then change to vertical to see which is better for the look you want. The size of the main subject relative to any other objects in the composition can change the meaning of the picture completely. Move closer or change your position (your angle of view) to get rid of distracting things in the background or foreground. Crouch down or lie on the ground if it will make a better picture.

Should you photograph the whole scene or just a small detail? What part of your subject appeals to you the most? Make a picture of just that small part, excluding everything else. This small part can represent the whole subject.

You can use lines or objects to create a *framing device*, which will direct the eye toward the subject. Patterns that are repeated can be used to emphasize the subject. Objects in the background that are similar in shape to the main subject can also make the image more interesting.

A standard composition is a balanced one. If there is a large object on one side, there is usually something to balance it on the other side. This is only a general rule. It can be bent or broken, often with wonderful results.

Cutting off part of your image with the frame of your viewfinder is called cropping. This should be done with care as it can change the meaning of the photograph. Pay special attention when cropping off someone's feet, hands, or head. It could be creative or just look like a mistake, depending on how well you do it.

You can make the subject fill the frame and seem very large, or combine it with other things and make it seem small. For dramatic effect, you can place the subject off-center, leaving empty space around it. Doing this can make a runner who has just lost a race seem sad, for example. The space isolates the subject and alters the mood of the photograph, giving it more meaning.

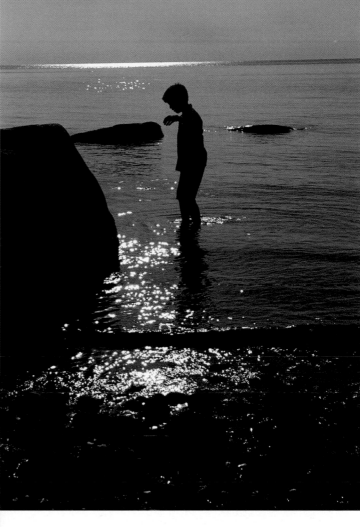

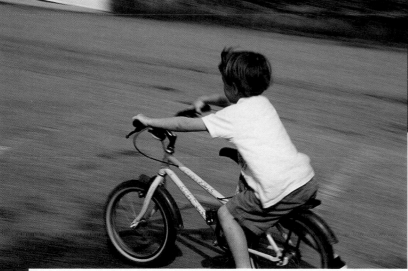

You don't have to hold your camera straight all the time. Taking pictures at odd angles can create different moods. For example, a picture of a galloping horse or a moving bicycle taken at an angle can help give the impression of speed.

# 6      natural light

The word *photography* comes from Greek and means "drawing with light." A photograph is produced when rays of light are arranged by the camera lens so that the film receives a clear image of whatever the light has illuminated.

Think about the light that falls on your subject. Most pictures are made in the natural light of day. Natural light is constantly changing. What a picture looks like depends on the time of day it was taken and the weather conditions at that moment.

In the early hours of the day, the sun is just rising, so colors are soft and shadows are blurred.

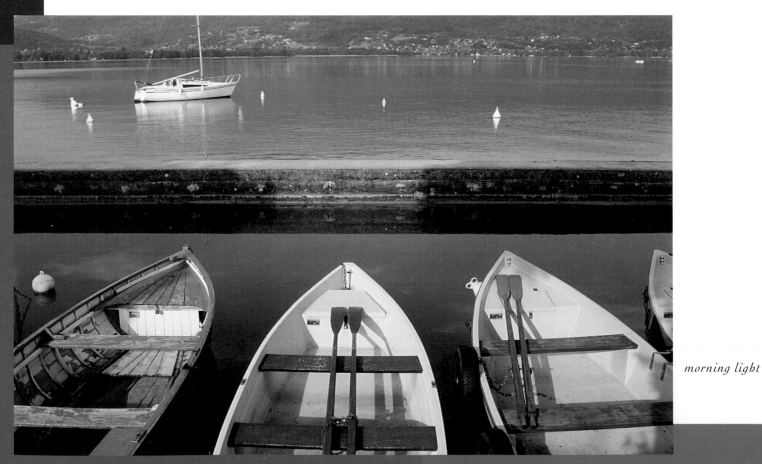

*morning light*

*mid-day light*

At mid-day, the sun is high in the sky and the light is harsh. Shadows are black and sharp and colors are very bright. If you take a picture in the shade at this time of day, it may have a bluish cast caused by light reflected from the sky. You can use a *filter* on your camera lens to correct this, or use your flash. You can also use a flash when you photograph faces in full sunlight to eliminate deep shadows under the eyes and chin.

In the late afternoon, shadows are long and dark, and can become an important part of the picture. Your subject is lit from the side at this time of day, so textures become more noticeable. It's a good time to photograph such subjects as an elderly person with weathered skin or a rocky

hillside. You might not want to photograph people right at sunset, because the light can make your subject look slightly orange!

## Weather

Sunny days are ideal for taking photographs outside, but you can take good pictures in all kinds of weather. Rain softens colors and makes surfaces shiny. Storms introduce drama and a sense of mystery. When taking photographs in rain or snow, you can protect your camera by covering it with a plastic bag (cut holes for the lens and viewfinder).

*late-afternoon light*

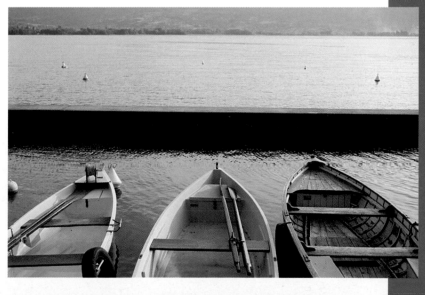

## Shadows

Shadows are very important because they can give your subject clear outlines and texture. They are especially useful in landscape photography or when you are taking photographs of favorite objects. The shadows become a dramatic part of the design of your picture, and can be almost as important as the main subject.

Be careful when you take pictures of people in the shadow of a tree. The dappled light from the leaves and branches will cast spots of shadow on your subjects. If you have no choice, use your flash to correct the problem with additional light. Always keep in mind that your camera will not capture exactly what your eye sees. Shadows or bright highlights will always look much darker or lighter in pictures.

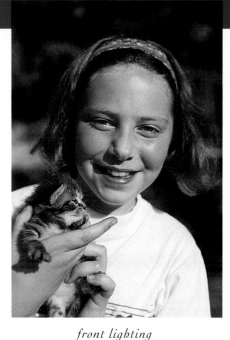
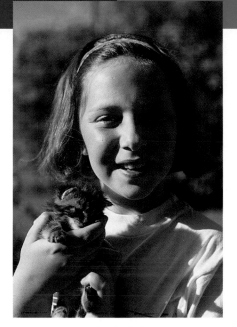
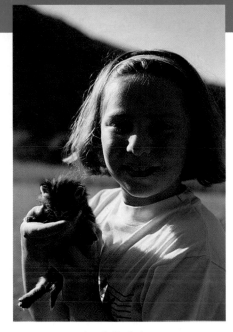

*front lighting*          *side lighting*          *back lighting*

## Angle of Light

Before you take a picture, consider where the light is coming from.

Front lighting occurs when the sun is behind you and the light falls directly on the subject. This is the "safest" light — in most situations your pictures will turn out well in this light. But it's very *flat light*, shadowless and not too interesting. Try to experiment with light from other angles as well.

Side lighting occurs when the light is falling on the side of your subject from the early morning or late afternoon sun. It can also be window light indoors. Experiment with the shadows — they will be long and interesting. You can make something ordinary look mysterious.

Back lighting is when the light in the background is much brighter than the light on the subject. It is difficult light for the meter in your camera to read correctly. You should set your exposure for the subject and let the background be overexposed (washed out). You can also use your flash to add light to your subject. If you shoot toward the sun, make sure to "hide" it behind a tree or other object. If you don't, a circular reflection called a lens flare may appear in your photograph.

The light from the setting sun is soft and won't usually cause lens flare. Shooting into the

sun or into any area much lighter than the foreground will cause everything else in the image to appear as a dark shape, or *silhouette*. This can look great, except when you're taking a picture of a person and you want to see more than a silhouette. In this case, use your flash to add light to the face. By using a slow shutter speed with an SLR camera and flash, you can prevent sunset colors in the background from looking washed out.

## Make a Sketchbook of Light

Take a series of photographs of the same subject, perhaps a building on a city street or a landscape in the countryside. Take one photo early in the morning, and others at noon, mid-afternoon, and just after dinner in the evening. Make another series in bright sunlight, on a cloudy day, and in the fog or rain. Try making pictures with front, side, and back lighting. Put all the pictures side by side and compare them.

You could make an album of photographs of your friends taken in different places at different times and under different weather conditions. As you turn the pages of the album, see what impressions and feelings you get from each picture.

## Color of Light

Light has several colors, depending on its source. This is important to remember when you are using color film. Most film is *color balanced* for daylight, that is, outdoor light from the sun. This means that all the colors in pictures taken in daylight will look natural when you use this film.

When you take a photo with daylight-balanced film inside the house, and lamps or track lights are turned on, the picture will have an orange tinge. If you photograph inside an office with fluorescent lighting, your picture will have a green tinge. These color problems can be corrected by using special filters on your camera lens, or an electronic flash used indoors will correct the color. The flash produces light the same color as daylight.

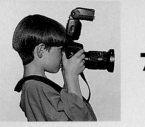

# 7 flash

Every photographer needs artificial light from time to time to make pictures in low light or in darkness. A flash may be built into your camera, or you could use a separate flash unit that you can attach to the camera.

Flash provides a very bright light, similar in color to daylight. The exposure you use depends on the distance between you and your subject, and is adjusted by changing your f-stop only. If your flash is powerful, you can stand farther away from your subject, but don't try to light up a whole gymnasium.

When you take a group photograph, make sure that all the people stand about the same distance from your camera. One person standing behind the others won't get enough light from the flash and will be underexposed, or too dark.

Flash "freezes" motion like a very fast shutter speed does. This may help you make a sharp picture when your subject is moving fast and there's not much light.

If your subject is directly in front of a white wall, an automatic flash will be fooled by the light reflected from the wall. The subject may be underexposed and come out too dark. If your subject is in front of a black wall or in a room with almost no light at all, the flash may be fooled again. The subject will be overexposed and look washed out in the picture.

*overexposed*

*underexposed*

You can help eliminate *red eye* by turning on room lights or by having your subject look away from the flash. Most new cameras and flashes have built-in red-eye reduction features, but using room lights is still a good idea.

When photographing people outdoors, you can use a flash to add extra light. This is called *flash fill*. The flash will eliminate shadows on the face, or keep the person from turning out too dark if the background is very bright. Don't use fast film in bright daylight when using flash fill — there will be too much light for the film speed.

If you're shooting into a mirror with your flash, make sure you can't see your own reflection. That way there won't be flashes of white in your picture. Stand at an angle to what you're photographing whenever there's a shiny surface behind your subject.

## How to Use a Separate Flash

Try to get the most powerful flash you can afford. If a new one is too expensive, buy a good used flash. A tiny flash won't give you the light you'll need.

Even if it has a built-in flash, most SLR cameras have a hot shoe above the viewfinder. You can slide a more powerful flash onto this

metal clip, and it will fire when the shutter button is pressed. When you use a flash on the hot shoe, don't set your shutter speed faster than the flash *sync speed* of your camera shutter. (Information about the sync speed for your camera is in the instruction booklet.) Most camera shutter speeds must be set at 1/125 second or slower when using a flash. If you want a lighter background, use a slower shutter speed (for example, 1/60 second or 1/30 second) with a flash.

## Flash Exposure

When using a flash, the exposure is set only with the f-stop on your lens. The correct f-stop is determined by the distance between your subject and the camera. There is a scale on the flash that tells you what f-stops to use at certain distances. A light meter in the flash will give you the correct exposure as long as you remain at the same approximate distance. The scale may look like this, although it will vary depending on the power of your flash and the speed of your film.

    Up to 10 feet (3 m) = f/16
    Up to 20 feet (6 m) = f/8
    Up to 30 feet (9 m) = f/4

A "dedicated flash" is a separate flash that can be used only with the make and model of camera it was designed for. This type of flash automatically sets both shutter speed and f-stop for correct exposure.

If the light from the flash is too harsh, you can soften it by covering the flash head with a *diffusing material,* either a single layer of lightweight white cloth or tracing paper.

If the flash head is adjustable, you can make the light from the flash less flat and more natural-looking by bouncing it. Frame your subject in the viewfinder and turn the flash head to point straight up at a low white ceiling or sideways at a light-colored wall. Using a bounce flash requires about one stop more exposure than a normal, straight-on flash. If the scale on your flash reads, for example, f/11 at the distance you are standing from your subject, change it to f/8.

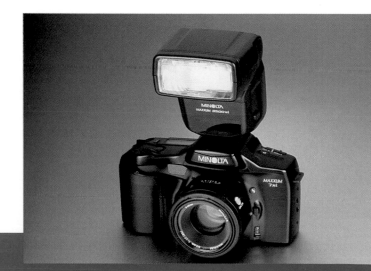

# 8                                 landscapes

To compose a picture of a landscape, try framing sections of the scene with the viewfinder. The section you choose will reflect what interests you in the landscape. Your photograph should contain an object, color, or pattern that attracts the eye. This gives the picture a center of interest.

You don't have to include everything in one shot. If you keep the composition simple, your photograph will have more *impact*. Impact is the strong feeling you experience when you look at a powerful image. It can make you feel happy, sad, or angry. For good examples of this, look at photographs in newspapers and magazines.

The *horizon line* is the line that separates the earth from the sky in a landscape. If the sky contains dramatic clouds or a sunset, place the horizon line very low in the frame to emphasize the sky.

When there are beautiful patterns in the land and the sky is plain blue or gray, the horizon line should be higher in the frame.

Place the horizon line near the center when the sky and the land are equally interesting.

Light and weather play an important part
in how your photographs will look. A stormy
sky or brilliant sunshine with deep shadows can
transform a dull place into a scene full of mystery
and drama. Soft morning light or fog can produce
a very different, peaceful feeling.

Be sure to look for close-up photographs in the landscape. A small detail of brightly colored flowers, combined with some interesting rocks, can make a picture that represents a much larger view of the landscape.

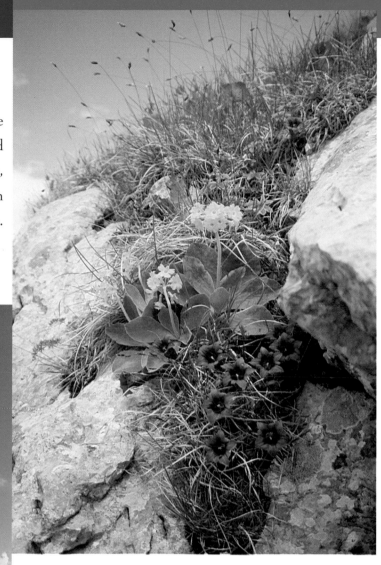

If you have an SLR camera, you can use filters to improve your pictures. A polarizing filter will intensify color in the landscape. It will also reduce any reflections from water and other surfaces.

# 9                              cityscapes

Taking pictures on a city street is a lot like taking landscape photographs — you have to decide what part of the scene to photograph. Think about what you would like to show others about this particular city. The buildings may be tall and crowded together, but that's true of many cities. If you live in a city, choose something personal to say about your neighborhood or some of your favorite places. Try the same thing in other cities when you're traveling.

You might try to photograph the contrasts between old and new: historical buildings beside modern skyscrapers, old railroad yards beside elevated expressways.

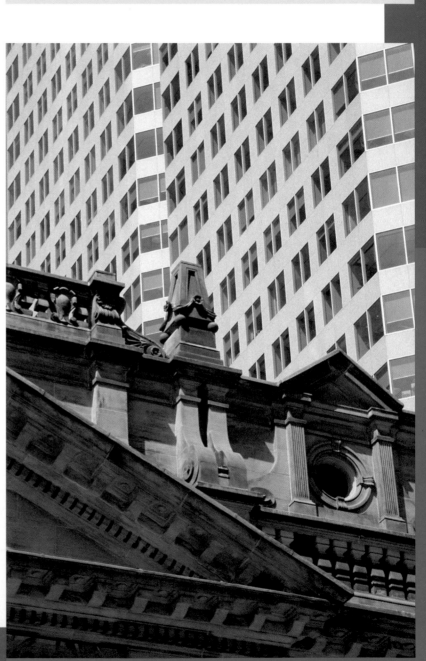

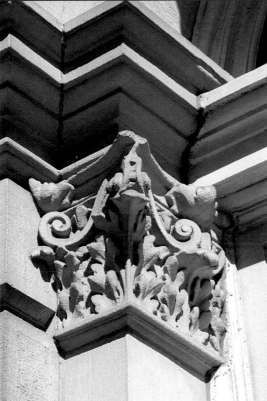

Take pictures of architectural details or reflections in windows. Remember, you don't have to fit the whole building into your picture.

Photograph people at a special event in the city — at a parade or an open-air market. Is there anything that makes the people in this particular city different from people elsewhere? Look for splashes of color (awnings, doors, flags, street signs) to create a center of interest for an otherwise gray cityscape. People with brightly colored clothes or umbrellas can also enliven a street scene, especially on a rainy day or in soft early morning light.

Repeating patterns of reflections on the shiny windows can make an interesting picture.

Crouch low or stand on a wall or monument to find a different, more dynamic, angle of view on an otherwise ordinary building. Try to exclude details that don't seem important. Keep the composition simple.

You can use a telephoto lens from ground level for extreme close-ups of statues or architectural details high on the walls of buildings.

If you're using an SLR camera, you may want to use a wide-angle lens to include more in your picture. When you point your camera upward, you'll notice that the sides of the buildings appear to converge (to come together almost to a point at the top). This is called *perspective distortion*. If you are able to stand far enough back from the building, the distortion will disappear. In the city, this is usually impossible. Photographers who have to shoot buildings with a 35mm camera use a special lens (perspective control lens, or PC lens) to help correct the problem.

Panoramic cameras take pictures almost 180° wide that can capture an entire skyline or city street. Single-use panoramic cameras are handy for vacations. You can take a city panorama from a tower or hill overlooking the city.

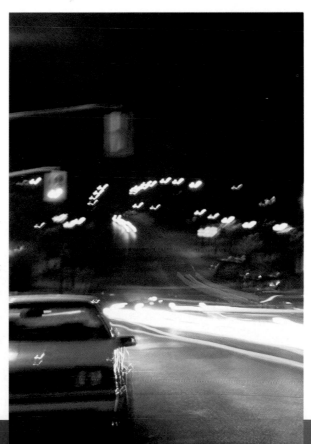

With a very slow shutter speed, high-speed film (at least 400 ISO), and your camera mounted on a tripod, you can photograph street scenes at night and let the lights and the sky create special effects. Patterns formed by the headlights of moving cars can be especially striking.

**school**

Taking your camera to school for several days can be fun. Make pictures of a variety of things. After they're printed, sort them by subject and decide which ones are the best pictures of the most interesting events. Include ones that seem to capture the mood of the event or of your class. From these, make a selection for your album. This is called a *photo essay*. Don't forget to write comments describing the event and the date under each picture.

For ideas of what to photograph, think about what activities you like and what you see at school each day. Is there a track meet coming up? Are there any clubs, such as a gymnastics club, or a band? There might be a science project you could document. What do your classmates do at recess or after school? Photograph some games: soccer, catch, hopscotch, basketball.

How about taking pictures during art class, music lessons, or even math class (with your teacher's permission)? At lunch-time you can take pictures of your friends eating lunch or just hanging around.

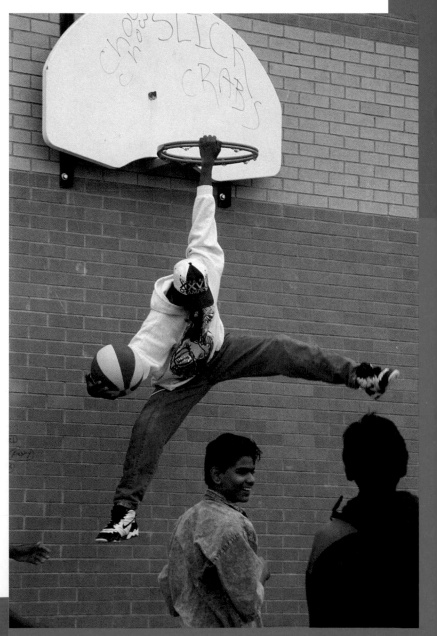

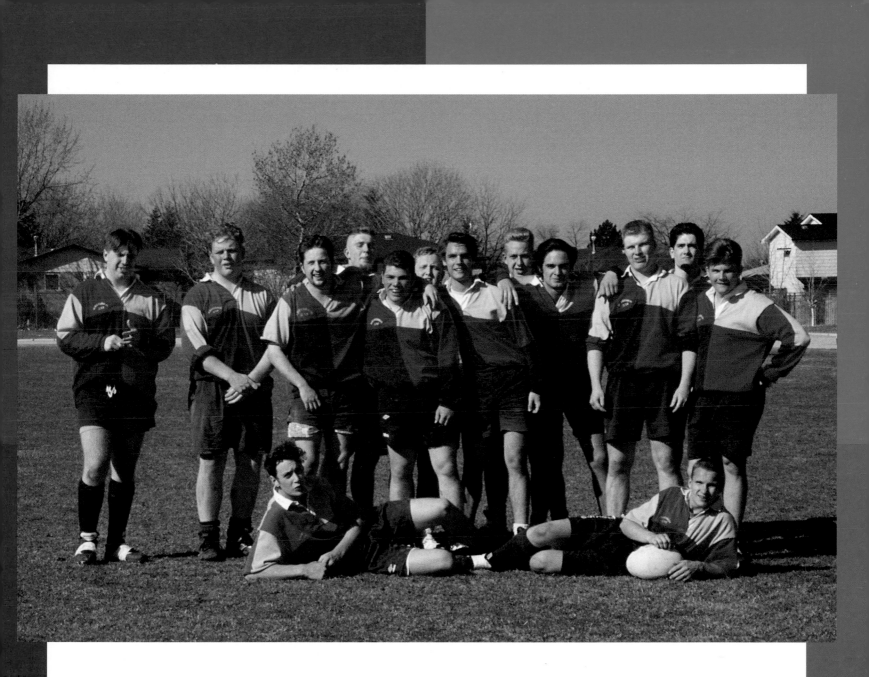

Suppose you have been asked to photograph a special event, such as the science fair or the school play. Perhaps the yearbook editor wants you to take candid pictures of kids in the graduating class. Maybe you are a member of a club or team and want to do a group portrait. One way to photograph a group is to make a standard portrait.

For something different, try to photograph the group celebrating after a victory or just hanging out together. Make sure you can see all their faces!

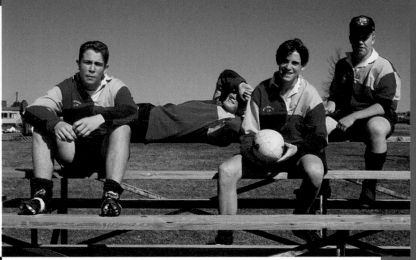

You'll probably have to tackle some technical problems when taking school photos. For dim light in school buildings, use high-speed film (400 ISO), and use your flash for indoor shots or even outside when it's cloudy or very sunny. Crouch low to photograph little kids from their perspective — it's a better angle of view.

You can use an 80A filter on the lens to correct the orange hue of standard indoor lighting. Under fluorescent lights, you must use a fluorescent filter or your pictures will look slightly green.

Use a flash when taking portraits, as long as your subject is not too far away. Try to photograph your favorite teachers in a way that reflects their personalities. Will you pose them or catch them unawares? Are they best sitting down or in action? Try different angles and take time to frame the person carefully in the viewfinder.

Special events, such as a play, held in an auditorium are likely to use spotlights, which present some special challenges. The light is not very bright and the people onstage are moving, so use fast film (400 ISO or faster). An 80A lens filter will give accurate color balance with standard, daylight-balanced film. If you are shooting slides, use a film such as Ektachrome that's balanced for *tungsten light.* Get close to the subject and hold your camera firmly, with your elbows resting on the edge of the stage. Try to shoot quickly.

If you're using a telephoto lens, your depth of field will be short. Focus carefully on the main subject of your picture. Use as small an aperture as possible for maximum depth of field.

For very low light, you should "push" the speed of the film. For example, use 400 ISO film but set your light meter at 800 or even 1600. This will give your film more speed so that in dim light you can use a faster shutter speed. You must use the higher ISO for the whole roll of film. Write the ISO number you used on the cassette with a marker as soon as you take the film out of the camera. Tell the photo lab that you have pushed the roll and give them the higher ISO number. The film will then be specially developed.

To push other kinds of film, double the normal ISO rating to give one stop more speed. Double it again for two stops. For example, if you're using 100 ISO film, for one stop more speed, take the whole roll at 200. For two stops, set the ISO dial at 400. For tungsten-balanced slide film with a normal rating of 160, push it to 320 (one stop) or 640 (two stops). Don't forget to mark the cassette.

Making portraits of your family and friends is
a good way to learn how to photograph people.
Look at the faces you know well and see if you
can pick out features and expressions that really
define a person for you. A portrait is your
impression of what the other person looks like.
If several people take pictures of the same person,
they will turn out quite differently.

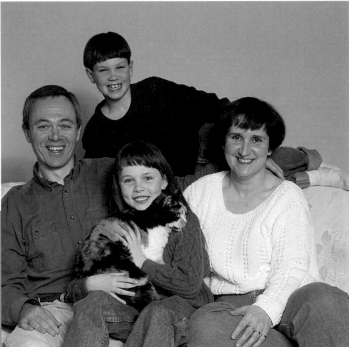

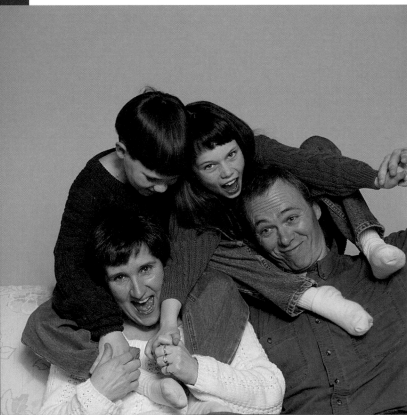

Portraits may be candid or posed. Posed
pictures are easier for the photographer to
control. There is time to arrange the composition,
camera angle, and lighting. But with fast film and
good lighting or flash, it's easy to take candid
pictures of people in action.

Try to make portraits of people in a place they feel comfortable. Talk to them as they pose. Try to time your photograph so they don't know exactly when you're pressing the shutter button. They'll appear to be more relaxed in the picture.

The face is generally the most interesting part of the body because it's where we show our emotions most clearly. Look for different expressions or even funny faces. A close-up picture of the face, or part of it, can be an effective portrait. Try for unusual angles when making these photographs. You could experiment with adding the person's hands or some background objects.

Light is very important. Front lighting and flash eliminate shadows on the face and make it look rounder and the skin look smoother. Light from the side makes the face more dramatic and shows textures and wrinkles more clearly. A simple image of someone's hands or feet can make a portrait that reveals a great deal about a person.

Consider your viewpoint when making a portrait. Get down on the floor right next to a baby. Point the camera slightly up at a man's face if he's balding. Don't photograph someone lying on a beach chair with legs jutting into the foreground — the legs will look huge!

As a special project, you could spend some time this year documenting your family's activities, both separate and together. Take pictures of your cousin playing tennis, your baby brother in his crib, your sister with her softball team. Document your summer vacation. You could make a little book of your best pictures as a gift.

For close-up portraits, you can use a normal 50mm lens, but there may be some distortion if you include more than a person's head. If you use a short telephoto lens (85mm to 105mm), you will

get better perspective and the arms and legs will all be in proportion to the head. A telephoto lens will also allow you to stand farther from your subjects, helping them to be a little more relaxed.

If the background is distracting and you'd like it to be out of focus, set your f-stop at a large aperture such as f/2.8 or f/4 and focus carefully on the face (the eyes are a good place). If you're photographing more than one person, you must either line them up side by side or use a smaller aperture (f/8, for example). Otherwise, the person behind could be out of focus.

Group pictures are important to family and friends. They're difficult to shoot because you have to be careful that you can see everyone clearly and that they're all in focus. Position the family in a friendly, informal way. Try to show the relationships between various people in the group.

To include yourself in a family photo, use the camera's self-timer. Put the camera on a tripod or a table and focus carefully on the group. Set the self-timer and move quickly to position yourself within the group before the shutter clicks.

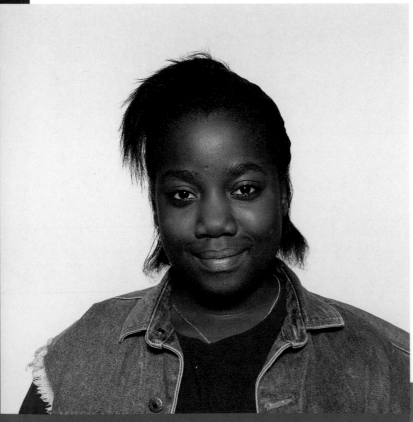

You could make a family tree. Take pictures of the people in your family — grandparents, parents, aunts and uncles, brothers and sisters, cousins. Make copies of old family photographs. Draw a tree with colored pencils or markers. Glue the old photographs with the new ones in chronological order on the tree. Write in as much information about the history of the different branches of your family as you can find.

To copy old photographs with your camera, first tape them carefully to a large board and place the board outdoors. The light should be as even as possible. Focus carefully. Use a telephoto lens if you have one. If not, get as close as you can focus to make the picture as large as possible. You could also use a macro lens to focus close up on small pictures. When you get the prints back from the lab, trim off all the borders with scissors.

Do you like stuffed animals? What sports equipment do you use? Do you have a collection of baseball cards, stamps, comic books? What's your favorite outfit? Do you play a musical instrument? Do you have a new bike? Photographing objects can tell a story if you use your imagination.

Victoria

If you create a photo album of your favorite things, you'll be able to remember them clearly in the future. Write notes under each photograph.

You could make a portrait of someone by taking pictures of the things they like to collect. Take a good photograph of the person and surround the photo with a collage of pictures of their favorite things. Consider mounting the collage on poster board or framing it as a birthday present.

Keep the pictures simple. Don't put too many things in the same photo. Experiment a bit with different arrangements of shapes before you take your picture. You have to choose which objects to include, what the background will be, and what camera angle to use. Start with a single, usually larger, object and then add others to complete your arrangement.

Look at the light. Strong shadows can change the shape of objects. If you need more light, take the objects outside in the sunshine or photograph them by a window. If you are using an SLR camera without flash, set your lens on the smallest f-stop possible for the available light and use fast film. If you want all the objects in sharp focus, shoot directly down at them from above with the light either behind you or from the side. That way, all the objects will be about the same distance from the film and will all be in focus.

# 13

# pets and other animals

Try taking pictures of a day in the life of your pet. What does he or she do all day? Try to capture your pet's unique character in a photograph. Make a portrait of him or her in the same way you would photograph a friend. Use the self-timer and take a picture of the two of you together.

in color. Look for a cute expression and make a close-up of the animal's face. If your pet can do any tricks, photograph them.

Many animals work for a living. You could photograph a dog in the K-9 corps of your local police force or a seeing-eye dog. What special qualities do these dogs have? There are horses that work as well, but not nearly as many as in the past. Can they still be found?

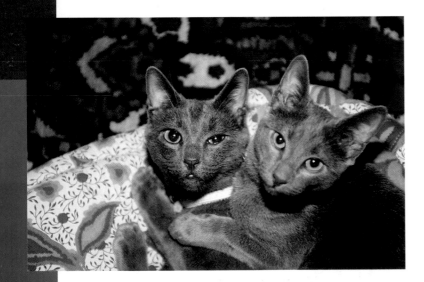

Most photographs of animals have to be taken in a hurry. Unless they are asleep, animals are usually moving. Use fast film (400 ISO) in bright light or use your flash, especially if your pet is dark

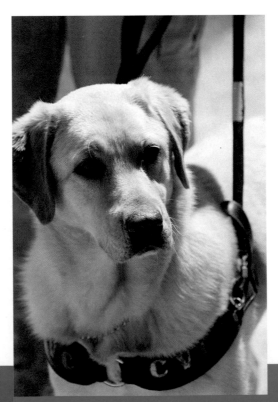

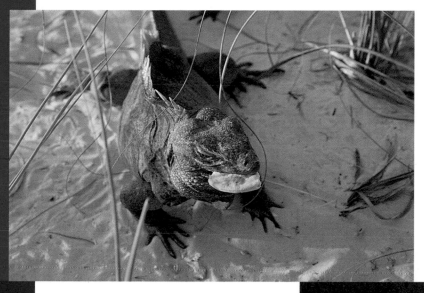

Some people have unusual or exotic pets in their homes. Take a picture of an unusual pet, such as an iguana, alone or with its owner.

It's possible to take good photographs of wildlife, but you'll need a lot of patience. A long telephoto lens (200mm to 300mm) is a great help when taking pictures of wild birds and animals. It will make the animal appear to be much closer than you could normally see it. Remember that these lenses are larger and heavier than normal, so you'll need a tripod.

The zoo is a good place to take exciting pictures. Try to keep the cage bars out of your composition. Make close-ups of animal faces with the telephoto lens. You could also photograph groups of animals to show the relationships between them.

# 14

# vacation
# and travel

Since the invention of photography in the nineteenth century, photographers have been making pictures of their travels. In the early days, they had to haul cartloads of equipment with them and process the large glass negatives as soon as they were made. With photography they could show people at home what faraway places actually looked like.

When you go on your next vacation or school trip, take your camera and make a travel journal — a series of photographs of the places you visit and the most interesting people that you meet. Choose your best pictures and paste them in sequence in an old-fashioned scrapbook with paper pages. Write your memories of the place and person under each photograph.

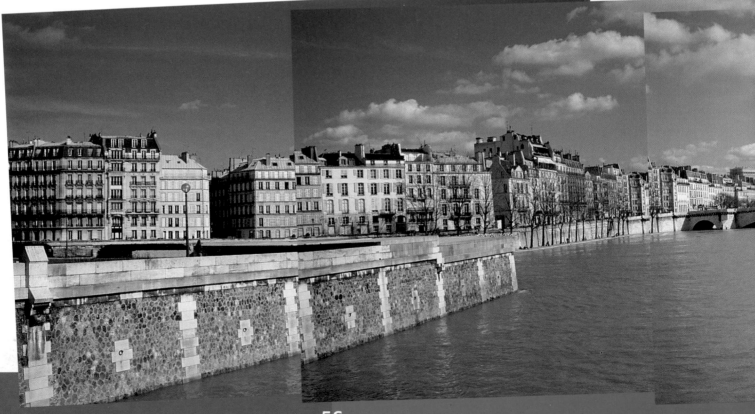

As the highlight of your vacation album, make a photomontage of a beautiful scene. Stand in one spot and rotate slowly from one side to the other, taking a series of several photographs, in sequence, of the scene in front of you. When you get the prints back, trim the sides and line them up so they fit together in a continuous panorama. You can achieve the same effect with less effort with a panoramic camera, which takes a continuous, side-to-side 180° scene in one picture (see page 43).

Using a book with blank pages, you could create a more detailed travel diary. It could include all your vacation experiences, both daily routines (such as swimming in the hotel pool) and special adventures (such as going on a boat along the coast). Write down the names of the places you visited, the dates of your trip, and any special memories. Illustrate your experiences with photographs.

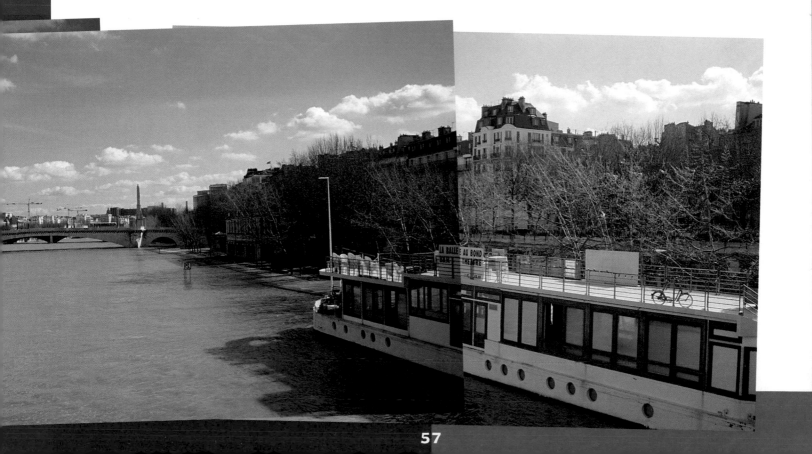

# 15

# sports

In action photography, the photographer tries to capture an impression of motion. There are two basic ways to show motion. One is by "freezing" the action with high-speed film and a fast shutter speed, or using a flash. The other is by creating a blurred subject or background to suggest motion.

With a point and shoot camera, you must use fast film (400 ISO) to freeze the action. Try to capture the moment when the action is at its peak. Catch the subject moving toward the camera or across your view. A flash will also stop action, but may bother the athletes.

A blurred image will show speed (see also page 60). *Panning* the camera will also show speed. When done carefully, it produces a blurry, streaked background but freezes the subject. The subject should be moving across your view. Pre-focus the camera on the spot where the subject will pass in front of you. When the subject comes into view, swing the camera smoothly to follow it

*freezing the action*

*blurring the action*

in your viewfinder in the direction in which it is moving. Follow it, take the picture as it passes in front of you, and continue to follow it with your camera after you have taken the picture. When you pan with a telephoto lens, move your camera much less than with a normal lens.

Take your camera to a gym class or to recess at school. Make pictures of kids doing gymnastics. Which movements are the most exciting? Photograph your friends as they rollerblade or skateboard, especially when they go over bumps. Pan them as they skate past you.

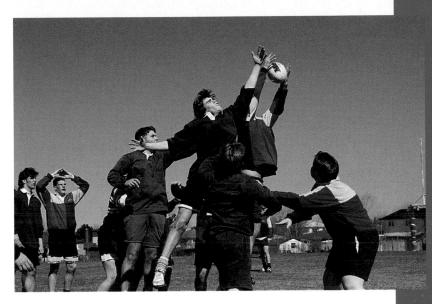

## Team Sports

Load your camera with a fresh roll of film before you start to take pictures of an important game. That way, you won't have to stop to change film during the most exciting moments. Use fast film and a very fast shutter speed (1/1000 second or faster) to capture the action. A large aperture will give short depth of field, which will make the background blurry and help focus attention on the players. Make sure you're not aiming into the sun. The light should be behind you or low in the sky to the side.

Look for interaction between the players as they chase the ball or puck. Get as close as you can. If you use a long telephoto lens, support the camera with a tripod. Choose your moments carefully. The action peaks just before it changes direction and that is the best moment to shoot. Look for the emotional reactions of players and coaches.

Try to find some unusual angles to photograph the game. For example, you could shoot down on basketball players at the hoop from a balcony above the court.

Take pictures of the cheerleaders, players in the locker room, faces in the crowd, whatever you think would help to capture the whole sports event.

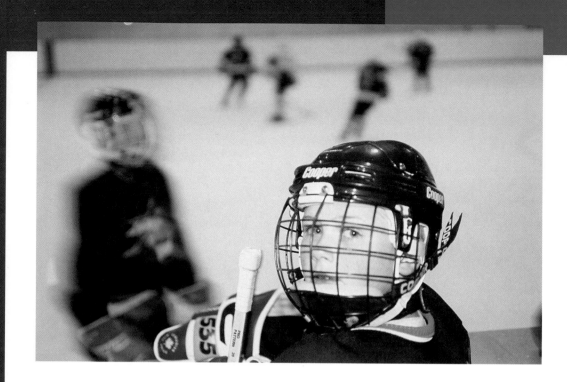

## Special Conditions

When you take pictures of skiing, hockey, or other sports on ice or snow, the white ground confuses the light meter in the same way as back lighting does (see page 31). As a result, skiers or hockey players end up too dark (underexposed). Use very fast film and look for a darker background such as trees (for ski shots) or the other side of the arena (for hockey). The meter will read the players instead of the snow or ice and give you a correct exposure. If you must shoot down onto the white ground, open up your lens one f-stop. Use a short depth of field to minimize the background (f/4).

Stand along the sides of ski hills and do some panning of skiers as they pass by you. You can get some interesting effects, and it's safer too.

You can make blurred images by using a slower shutter speed (1/15 to 1/60 second) and keeping the camera still and supported on a tripod when shooting a moving object. The blur will give a strong impression of motion. How much the picture is blurred depends on the speed of the object and the speed of the shutter. As you increase the shutter speed, the blur will be reduced and eventually the image will appear perfectly sharp (at about 1/250 second or faster).

# 16 special effects

## Close-up Photography

A close-up photograph is one in which the subject is focused at closer than 3 feet (1 m) from the camera. It's not possible to take close-up shots with a point and shoot camera unless it has a *macro* feature. When shooting close-ups, it's a good idea to use a tripod because the focus will change with the slightest movement. Also, use a small aperture to give some depth of field.

Try some close-ups of translucent objects like flowers or stained glass. Light them from behind to make the colors glow.

## Underwater Photography

Inexpensive underwater cameras are perfect for making pictures in swimming pools or while snorkeling. They are also very good for use in the rain or at the beach. There are even disposable models you can use to take one roll of film while you're on vacation. Read the instructions carefully before taking your camera underwater.

Take underwater pictures of people swimming in a pool. Bubbles and water reflections add interesting effects.

In the shallows of the ocean, photograph whatever you find on the bottom. The built-in flash brightens underwater colors. Use some fast film and chase a school of colorful fish!

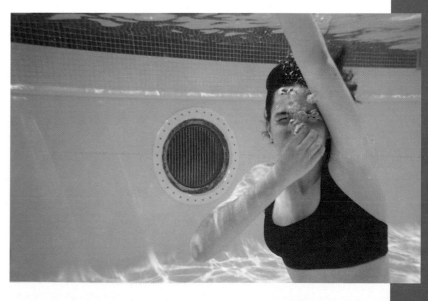

## Photography of the Future

Cameras will always be important, but the technology of photography is changing rapidly. Photography by computer (*digital imaging*), using special cameras and software, is an exciting new area.

You could have one of your photographs scanned into a computer. Once it's a digital image, you can change it with software programs. For example, you could scan in a portrait, then add objects and tints to create a new picture. You can then have the image printed on paper or on a T-shirt.

# glossary

**angle of view**  The angle at which the camera is held when pointed at the subject. (pages 17 and 22)

**aperture**  The opening in the lens is called the aperture. It can be made larger or smaller to increase or decrease the amount of light that reaches the film. (page 11)

**bracketing**  If you're not sure about the exposure, you can take one frame at the meter reading and bracket it by changing the exposure setting to overexpose the next frame by one stop and underexpose the following frame, also by one stop. You will then have three negatives. Bracketing ensures that you'll have one good negative. (page 22)

**center of interest**  The most interesting thing in the photograph — an object or person, color or pattern, that attracts the eye. (pages 16 and 36)

**color-balanced film**  Most film is color balanced for daylight. This means that all the colors in pictures taken in daylight will look natural when you use this film. (page 32)

**composition**  Composing a photograph is a little like drawing a picture — you must decide what to include within the frame. Simple compositions are usually best. (page 16)

**depth of field**  The region of sharp focus around the subject is the depth of field. Short depth of field gives a fuzzy background; with long depth of field, everything is in focus. (page 19)

**diffusing material**  If the light from a flash is too harsh, cover the flash head with diffusing material — either lightweight white cloth or tracing paper. (page 35)

**digital imaging**  When photographs are scanned into a computer, they can be manipulated and changed using computer software. This is called digital imaging. (page 62)

**DX code**  If a DX code is stamped on the film cassette, the film speed will be automatically set. (page 13)

**exposure**  The combination of aperture setting and shutter speed controls the amount of light the film receives. This is called the exposure. (page 11)

**f-stop**  The lens aperture is divided into f-stops (focal-length stops), which change the size of the opening in the lens. (page 18)

**film cassette**  The round metal container that holds the film is the cassette. (page 13)

**filter**  Special filters can be attached to the lens to correct color balance. (page 29)

**flash fill**  When photographing people outdoors, you can use a flash to eliminate shadows and lighten the subject if the background is very bright. (page 34)

**flat light**  Light that falls directly on the subject without making shadows is called flat light. (page 31)

**focal length**  Different lenses have different focal lengths, which change the size of the image and determine how much of it will fit within the frame. (page 11)

**focus**  An image appears sharp and clear when it is in focus. (page 10)

**framing device**  Lines or objects can be used to create a framing device, which will direct your attention toward the subject. (page 26)

**horizon line**  The line that separates the earth from the sky in a landscape is the horizon line. (page 37)

**hot shoe**  The clip on the top of SLR cameras and some point and shoot cameras for attaching a separate flash. (page 12)

**impact**  Impact is the feeling you experience when you look at a powerful image. (page 36)

**ISO (International Standards Organization) number**  Film speed is indicated by the ISO number printed on the box and cassette. (page 12)

**light meter**  The light meter indicates the correct shutter speed setting. (page 13)

**macro**  A macro lens feature enables a point and shoot camera to take close-up photographs. (page 61)

**mat**  A piece of cardboard or other material placed over a photograph to serve as a frame or to provide a border between the photo and the frame. (page 14)

**negative**  When film is developed, the exposed silver coating of the film forms negative images in which dark tones look light and light tones look dark. When the negatives are printed, positive images are produced. (page 10)

**normal lens**  The all-purpose lens that "sees" the same way you see is a 50mm lens. (page 22)

**panning**  If you follow the movement of an object with the camera during an exposure, the object will be in focus against a blurred background. (page 58)

**perspective distortion**  When the camera is pointed upward at a building, the sides will appear to converge. This distortion can be corrected by moving back from the building or by using a special perspective-correcting lens. (page 42)

**photo essay**  By arranging photographs to tell a story and labeling them with names and dates, you can create a photo essay. (page 44)

**photography**  The word *photography* comes from Greek and means "drawing with light." A photograph is produced when rays of light are arranged by the camera lens so that the film receives a clear image of whatever the light has illuminated. (page 28)

**red eye**  When a flash is used, red dots sometimes appear in eyes. This can be avoided by turning on room lights or by having your subject look away from the flash. (page 34)

**shutter speed**  The speed at which the shutter moves to uncover and cover the film during exposure. (page 20)

**silhouette**  Shooting into the sun or into any area much lighter than the foreground will cause everything else in the image to appear as a dark shape, or silhouette. (page 32)

**silver**  Film has a silver coating that is sensitive to light. When the silver is exposed to light, it forms a negative image of the subject. (page 10)

**single-lens reflex**  More complicated than a point and shoot camera, the SLR allows manual adjustments to change and improve photographs. (page 10)

**sync speed**  A separate flash must be set at the sync speed of the shutter, usually 1/125 second. See your instruction booklet for more information. (page 35)

**telephoto lenses**  These lenses magnify the subject, bringing it closer and making it larger within the frame. Common telephoto lenses are 85mm to 200mm. (page 23)

**tungsten light**  This refers to artificial light in general, except fluorescent light, but particularly to spot lights. (page 47)

**viewfinder**  This is the tiny window in your camera through which you compose the photograph. (page 10)

**wide-angle lenses**  These lenses reduce the size of what you see so that you can get more of the subject into the picture. They are usually 28mm or 35mm. (page 22)

**zoom lenses**  These practical lenses combine focal lengths from wide angle to telephoto, allowing a wide variety of photographs. (page 23)